WHISTLER
1834 – 1903
BY T. MARTIN WOOD

PLATE I.—OLD BATTERSEA BRIDGE
(In the National Gallery)

This nocturne was bought by the National Collections Fund from the Whistler Memorial Exhibition. It was one of the canvases brought forward during the cross-examination of the artist in the Whistler v. Ruskin trial.

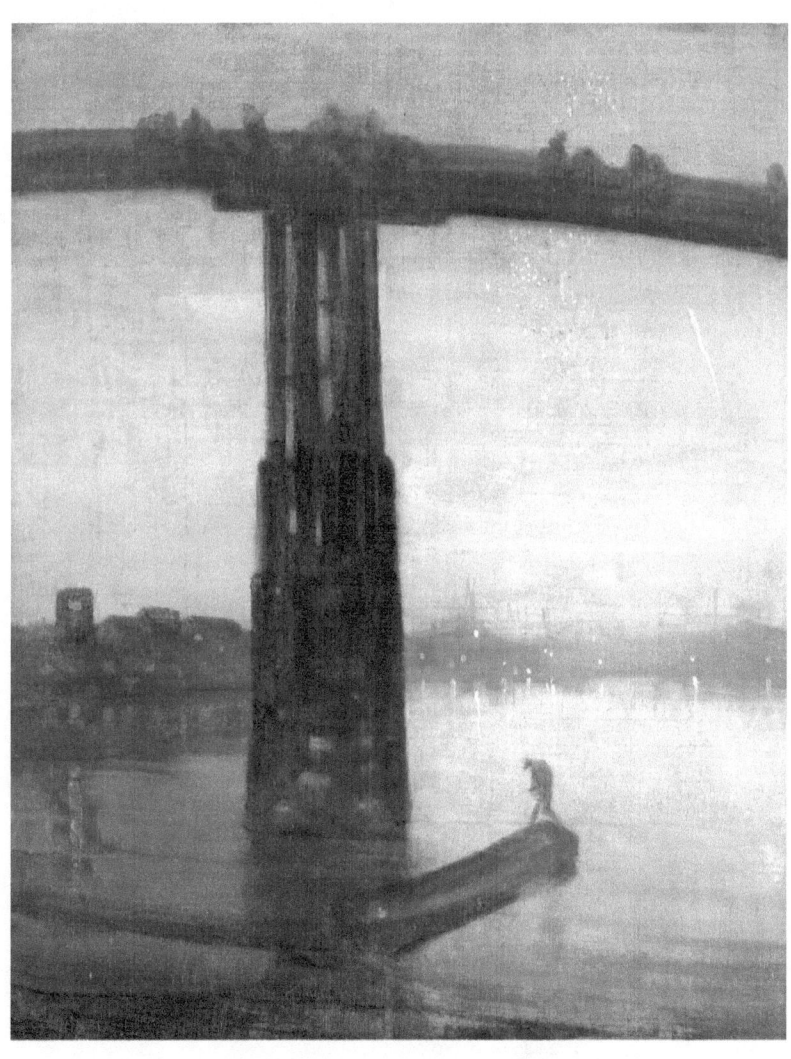

This book is an unabridged reprint of the first edition published by T. C. & E. C. Jack, London, and Frederick A. Stokes Co., New York, in 1908. Page numbers differ from the first edition.

Typeset and republished by Michael W. Gioffredi. Copyright 2019. MichaelGioffredi.com/ux4j

ISBN-13: 978-1-0779-7317-6
ISBN-10: 1-0779-7317-9

2 4 6 8 10 9 7 5 3 1

LIST OF ILLUSTRATIONS

Plate Page

 I. Old Battersea Bridge iii

 II. Nocturne, St. Mark's, Venice 11

 III. The Artist's Studio 17

 IV. Portrait of my Mother 23

 V. Lillie in Our Alley 29

 VI. Nocturne, Blue and Silver 37

 VII. Portrait of Thomas Carlyle 45

VIII. In the Channel 53

I

AT the time when Rossetti and his circle were foregathering chiefly at Rossetti's house, quiet Chelsea scarcely knew how daily were associations added which will always cluster round her name. Whistler's share in those associations is very large, and he has left in his paintings the memory of many a night, as he returned beside the river. Before Whistler painted it, night was more opaque than it is now. It had been viewed only through the window of tradition. It was left for a man of the world coming out of an artificial London room to paint its stillness, and also to show us that we ourselves had made night more beautiful, with ghostly silver and gold; and to tell us that the dark bridges that sweep into it do not interrupt—that we cannot interrupt, the music of nature.

The figure of Whistler emerges: with his extreme concern as to his appearance, his careful choice of clothes, his hair so carefully arranged. He had quite made up his mind as to the part he intended to play and the light in which he wished to be regarded. He had a dual personality. Himself as he really was and the personality which he put forward as himself. In a sense he never went anywhere unaccompanied; he was followed and watched by another self that would perhaps have been happier at home. Tiring of this he would disappear from society for a time. Other men's ringlets fall into their places accidentally—

so it might be with the young Disraeli. Other men's clothes have seemed characteristic without any of this elaborate pose. He chose his clothes with a view to their being characteristic, which is rather different and less interesting than the fact of their becoming so because he, Whistler, wore them. Other men are dandies, with little conception of the grace of their part; with Whistler a supreme artist stepped into the question. He designed himself. Nor had he the illusions of vanity, but a groundwork of philosophy upon which every detail of his personal life was part of an elaborate and delicately designed structure, his art the turret of it all, from which he saw over the heads of others. There is no contradiction between the dandy and his splendid art. He lived as exquisitely and carefully as he painted. Literary culture, merely, in his case was not great perhaps, yet he could be called one of the most cultured figures of his time. In every direction he marked the path of his mind with fastidious borders. And it is interesting that he should have painted the greatest portrait of Carlyle, who, we will say, represented in English literature Goethe's philosophy of culture, which if it has an echo in the plastic arts, has it in the work of Whistler. In his "Heretics" Mr. G. K. Chesterton condemned Whistler for going in for the art of living—I think he says the miserable art of living—I have not seen the book for a long time, but surely the fact that Whistler was more than a private workman, that his temperament had energy enough to turn from the ardours of his work to live this other part of life—indicates extraordinary vitality rather than any weakness. Whistler was never weak: he came very early to an understanding of his limitations, and well within those limitations took his stand. Because of this his art was perfect. In it he declined to dissipate his energy in any but

its natural way. In that way he is as supreme as any master. Attacked from another point his whole art seems but a cobweb of beautiful ingenuity—sustained by evasions. Whistler, one thinks, would have been equally happy and meteorically successful in any profession; one can imagine what an enlivening personality his would have been in a Parliamentary debate, and how fascinating. Any public would have suited him. Art was just an accident coming on the top of many other gifts. It took possession of him as his chief gift, but without it he was singularly well equipped to play a prominent part in the world. As things happened all his other energy went to forward, indirectly and directly, the claims of art. Perhaps his methods of self-advancement were not so beautiful as his art, and his wit was of a more robust character. For this we should be very glad; the world would have been too ready to overlook his delicate work—except that it had to feed his inordinate ambition. At first it recognised his wit and then it recognised his art, or did its level best to, in answer to his repeated challenges.

It is easier to explain Whistler's personality than his work. In his lifetime most people had recognised all the force of his personality, but it was not so with his art. In this he is as a player of violin music, or a composer after the fashion of the masters of music—his relationship to the subject which suggests the motif, of course, could not be quite so slight as theirs—but it was their standpoint that he adopted and so approached his art from another direction than the ordinary one. To a great extent he established the unity of the arts. Without being a musical man, through painting he divined the mission of music and passed from the one art almost into the other. And the effort above everything else for self-expression was in its essence a musical one too, as also the fact that he

PLATE II.—NOCTURNE, ST. MARK'S, VENICE
(In the possession of John J. Cowan, Esq.)

This picture was first exhibited in the winter of 1886 at the Royal Society of British Artists. The painter's election as President of the Society taking place just after the hanging of the exhibition. A newspaper criticism at the time was to the effect that the only note-worthy fact about the painting was the price, £630, "just about twenty shillings to the square inch." The figure of an investment, we may add, which was to improve beyond the wildest calculations.

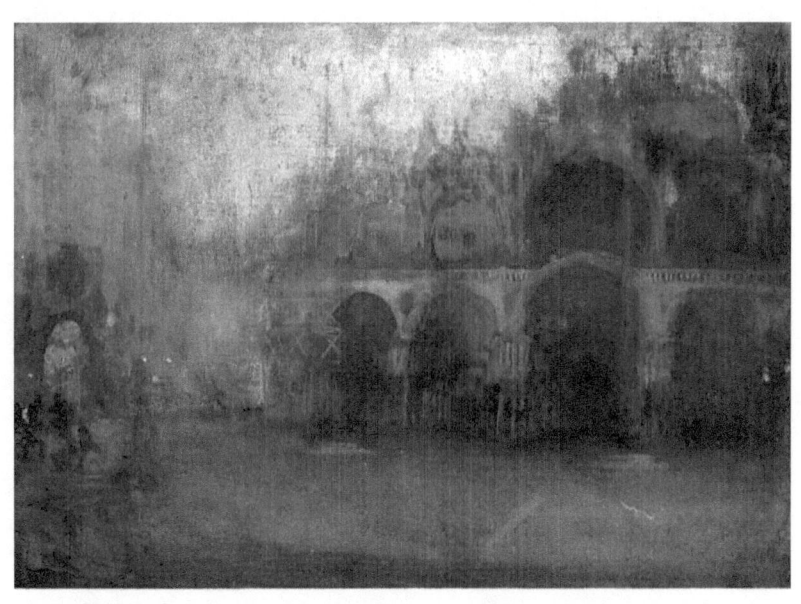

never allowed a line or brushmark to survive that was not as sensitively inspired—played we might almost say—as the touch of a player, playing with great expression, upon the keyboard of his piano. This quality of touch—how much it counts for in the art of Whistler—as it counts in music. It is one of the essential things which we have to understand about his work, to appreciate and enjoy it.

Both painting and music are so different from writing in this, that the thoughts of a painter and musician have to issue through their fingers, they have to clothe with their own hands the offsprings of their fancy. They cannot put this work out, as the writer does, by dictation to a type-writer. It is not in the style he lays the ink that the poet finds the expression, its thickness or its thinness bears no resemblance to his soul, but the intimacies of a painter's genius are expressed in the actual substance of his paint and in the touch with which he lays it. So in painting the mysterious virtue arises which among painters is called "quality," a certain beauty of surface resultant from the perfection of method. And it is "quality," which Whistler's work has superlatively, in this it approaches the work of the old masters, his method was more similar to the old traditions than to the systems current in the modern schools. And part of the remote beauty, the flavour of distinction which belongs to old canvases is simulated by Whistler almost unconsciously.

Mr. Mortimer Mempes has put on record the painful care with which Whistler printed his etchings. The Count de Montesquieu, whom Whistler painted, tells of the "sixteen agonising sittings," whilst "by some fifty strokes a sitting the portrait advanced. The finished work consisted of some hundred accents, of which none was corrected or painted out." From

such glimpses of his working days we are enabled to appreciate that desire for perfection which was a ruling factor both in his life and work. In art he deliberately limited himself for the sake of attaining in some one or two phases absolute perfection; he strained away from his pictures everything but the quintessence of the vision and the mood. He worked by gradually refining and refining upon an eager start, or else by starting with great deliberation and proceeding very slowly with the brush balanced before every touch while he waited for it to receive its next inspiration. So he was always working at the top of his powers. Those pleasant mornings in the studio in which the Academy-picture painter works with pipe in mouth contentedly, but more than half-mechanically, upon some corner of his picture were not for him. Full inspiration came to him as he took up his brushes, and the moment it flagged he laid them aside. So that in his art there is not a brush mark or a line without feeling. His inspiration, however, was not of the yeasty foaming order of which mad poets speak, but spontaneity. Spontaneous action is inspired. And this is why his work looks always as if it was done with grace and ease, and why it seemed so careless to Ruskin. However, such winged moments will not follow each other all day long, and though they take flight very quickly, work at this high pressure—with every touch as fresh as the first one—cannot be indefinitely prolonged. Whistler's friends regretted that he should suddenly leave his work for the sake of a garden party. It is more likely that he turned to go to the garden party just when the right moment came for him to leave off working and so conserve the result, for it is the tendency of the artist in inspired moments to waste his inspiration by allowing the work of one moment to undo what was done in the one before it.

II

THE wit of Whistler was not like the wit, let us say, of Sheridan, but it was the result of intense personal convictions as to the lines along which art and life move together. About one or two things in this world Whistler was overflowing with wisdom, and upon those things his conversation was always salt, his sayings falling with a pretty and a startling sound. He talked about things which were much in advance of his day. His was not the wisdom of the past which always sounds impressive, but the greater wisdom of the future, of instincts not yet established upon the printed page. By these he formed his convictions as he went, referring all his experiences, chiefly artistic ones, back to his intelligence, which as we know was an extraordinarily acute one. Other people's ideas, old-fashioned ones, coming into collision with the intensity of his own, produced sparks on every occasion, and this without over anxiety to be brilliant on Whistler's part. It is so with original minds.

There is a difference between artistic work and other sorts of work. Outside the arts, in other professions, what a man's personality is, whilst it affects the way his work is accomplished, does not alter the nature of that work. Immediately, however, the work becomes of such a nature that the word art can be inserted, then the personal equation is before everything to be considered. "Temperament" meets us at every turn, in the touch of brush to paper, in the arrangement of the design, in the subject chosen, in the way of viewing that sub-

ject, in the shape that subject takes. Also we can be sure that a picture suffers by every quality, either of mere craftsmanship or surface finish, that tends to obscure individuality of touch and feeling. Outside the arts every job must be finished, if not by one man then by another. A half-built motor-car means nothing to any one, it cannot be regarded as a mode of personal expression, but in art it is otherwise, no one can finish a work for some one else, and as Whistler pointed out, "A work of art is finished from the beginning." In such a saying Whistler showed the depths from which his wit spilt over. His intuitiveness in certain directions was almost uncanny, taking the place of a profound scholarship, and this saying is a case in point. For however fragmentary a work of art is, if it contains only a first impulse, so far as the work there is sufficient to explain and communicate that impulse, it is finished—finish can do no more. And of course this is not to say that art should never pass such an early stage. All this depends on what the artist has to say: sometimes we have to value above everything the completeness, the perfection of surface with which a picture has been brought to an end. Whistler's paradox sums up the fact that finish should be inextricably bound up with the method of working and the personal touch never be so "played out" that resort is made to that appearance of finish which can always be obtained by labour descending to a mechanical character. This may sound rather technical, but it is not so really.

Here we may remark on all that is due to Whistler, as to Manet, for disturbing the dust in the Academies, at one time so thick that the great difference between art and mere craft seemed almost totally obscured.

PLATE III.—THE ARTIST'S STUDIO
(In the possession of Douglas Freshfield, Esq.)

In this Whistler stands in profile before his easel. The picture belongs to Mr. Douglas Freshfield. There is another version, in a lower key and less finished, in the Lane gift at the City of Dublin Gallery, from which this was perhaps painted.

III

WHISTLER'S life is at present a skeleton of dates on which this incident occurred or that, and at which the most notable of his pictures appeared. And this must remain so until an authoritative biography of the painter has appeared. With whom the authority rests was made the subject of a recent Law Case. Till such a work appears we can only deal with his art and with the Whistler legend, the impressions, recorded and otherwise, he left upon those who were brought into contact with him.[1] These are strangely at variance—some having only met him cloaked from head to foot in the species of misunderstanding in which, as he explained, in surroundings of antagonism he had wrapped himself for protection; others remembering him for his kindliness and his old-fashioned courtesy.

Permitting himself sufficient popularity with a few to be called "Jimmy," Whistler's full name was James Abbot McNeill Whistler, and the initials gradually twisted themselves into that strange arabesque with a wavy tail which he called a butterfly and with which he signed his pictures and his letters. Born on 11th July 1834 at Lowell, Massachusetts, he was the descendant of an Irish branch of an old English family, and in his seventeenth year he entered the West Point Military Academy, where after making his first etchings on the margins of the map which he should have been engraving, he decided to devote his life to art. He was twenty when he left Amer-

[1] Since going to press, "The Life of Whistler," by E. R. and J. Pennell has appeared.

ica and he never returned to it, so that as far as America is concerned infancy can be pleaded. America has since bought more than her share of the fruits of his genius, finding in this open-handed way charming expression for her envy. He went to Paris to study art, where he was gay, and attracted attention to himself by the enjoyable way in which he spent his time. It was not until he was twenty-five that he arrived in London, and a little later moving to Chelsea commenced work in earnest.

A charming picture suggests itself of the painter escorting his aged mother every Sunday morning to the door of Chelsea old church, as was his habit, bowing to her as she enters and hastening back to the studio to be witty with his Sunday friends.

Whistler's first important picture, "At the Piano," issued from Chelsea. It was hung in the Academy in 1860 and was bought by a member of the Academy. He followed the next year with "La Mère Gerard," which belongs to Mr. Swinburne. He sent a picture called "The White Girl," to the Salon of 1863. It was, however, rejected. It was then hung at the collection called the "Salon des Refusés," an exhibition held as a protest against the Academic prejudices which still marked the Salon. There it met with an enthusiastic reception which set Whistler off on his career of defiance. In 1865 the painter went to Valparaiso for a visit, from which resulted the beautiful Valparaiso nocturnes. Back again in Chelsea, he devoted himself to the river there. He was then living in a house in Lindsay Row. At this time he was greatly affected by Japanese art, and one or two pictures show curious attempts to adapt scenes of the life of the West to the Eastern conventions. This phase of his art was beautiful, but he passed it on the way to

work of greater sincerity, and more clearly the outcome of his own vision. In 1874 the first exhibition of Whistler's work was held at a Gallery in Pall Mall, containing among other things "The Painter's Mother," "Thomas Carlyle," and "Miss Alexander." It is interesting that the Piano Picture, painted just as he emerged from his studentship, is of the flower of his art; he did things afterwards of great significance, and did them quite differently, but the Piano Picture does not seem a first work preparing his art for future perfection, it is so perfect in itself. And here perhaps we may observe another fact in connection with Whistler, that in the last days of his life he painted with the same genius for the beautiful as at the beginning; none of that deterioration had set in, which so often comes in the wake of flattery and belated public esteem. He was never betrayed by success into over, or too rapid, production. He never succumbed to the delight of anticipating a cheque by every post instead of bills. He found no difficulty in declining the most tempting offers. Well, work that is held thus sacred by its own creator, should tempt people to search for all that made it seem so valuable to him. Whistler had an intense dislike of parting with his work. When a picture was bought from him he was like a man selling his child. Sometimes he would see somewhere a picture he had painted, he would borrow it to add to or improve it, but he would keep it and live with it and gradually forget all about its possessor. Whatever qualms attacked his conscience for this procrastination, it was no part of his genius to confess, instead he would say "For years, this dear person has had the privilege of living with that masterpiece—what more do they want?" At Whistler's death, however, it was found that the circumstances under which a picture had at any time been borrowed were methodically entered up, with

PLATE IV.—PORTRAIT OF MY MOTHER
(In the Luxembourg Galleries, Paris)

This was first exhibited in the Royal Academy in 1872. For many years it remained in the painter's possession. It left this country to become the property of the French Government in the Luxembourg at the sum of £120. In "The Gentle Art of Making Enemies" Whistler writes of the picture as an "Arrangement in Grey and Black." "To me," he adds, "it is interesting as a picture of my mother; but what can or ought the public to care about the identity of the portrait?"

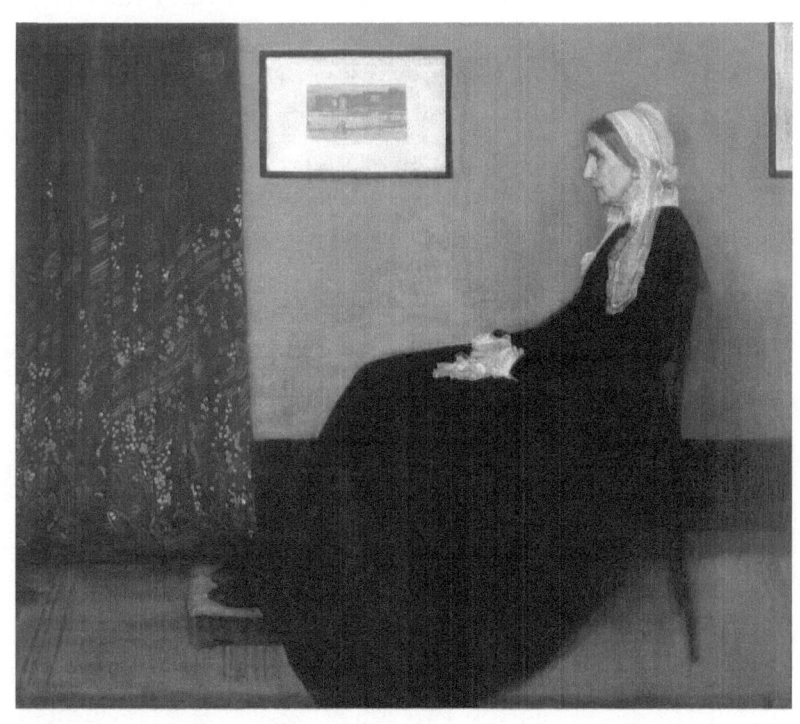

minute directions as to the return of one or two pictures, borrowed thus, that were in his studio when he died.

In Chelsea, Rossetti and Whistler were good friends, they shared a love of blue china, in fact inventing the modern taste for certain kinds, especially for what they called "Long Elizas," a specimen upon which slim figures are painted,—"Lange leises"—tall damsels—as they were called by the Dutch. One supposes that it is through Rossetti that he came into contact with Swinburne, who was inspired to write the poem called "Before the Mirror," by Whistler's picture "The White Girl," and of which some of the verses were printed after the title in the catalogue of the Royal Academy Exhibition. The first verse in itself suggests a scheme of white:—

> "White rose in red rose-garden
> Is not so white;
> Snowdrops that plead for pardon
> And pine for fright
> Because the hard East blows
> Over their maiden rows
> Grow not as this face grows from pale to bright."

The poem was printed on gilded paper on the frame; this was however removed on the picture going to the Academy, and in the catalogue the two following verses were printed after the title:—

"Come snow, come wind or thunder
 High up in air,
I watch my face, and wonder
 At my bright hair;
Nought else exalts or grieves
The rose at heart, that heaves
 With love of her own leaves and lips that pair.

"I cannot tell what pleasure
 Or what pains were;
What pale new loves and treasures
 New years will bear:
What beam will fall, what shower,
What grief or joy for dower;
 But one thing knows the flower; the flower is fair."

Later on, Swinburne did not allow the Ten o'clock lecture to go unchallenged, and he subjects its glittering rhetoric to a not unkind but cold analysis which, however, Whistler has the grace to print with marginal reflections in "The Gentle Art of Making Enemies," the book which contains the paradoxes which reflect so well his powers as a thinker. It is doubtful whether Whistler in kinder circumstances would have produced his brilliant theories. The irritation caused by misconception, the necessity of justifying even his limitations to a world which was apparently prepared to consider nothing else about him at one time—these were the wine-press of his eloquence. He disliked the rôle of teacher and apologised for it at the beginning of his "Ten o'clock," and when, in later life, following the fashion, he started a school, he relied upon the

example of his own methods of setting the palette rather than upon precept, with a little banter to keep good humour in his class-room. A young lady protested "I am sure that I am painting what I see." "Yes!" answered her master, "but the shock will come when you see what you are painting." A student at the short-lived Académie-Whistler has written that merely attempting to initiate them into some purely technical matters of art, he succeeded—almost without his or their volition—in transforming their ways of seeing! "Not alone in a refining of the actual physical sight of things, not only in a quickening of the desire for a choicer, rarer vision of the world about them, but in opening the door to a more intimate sympathy with the masters of the past."

The thing that strikes one in reading "The Gentle Art" is how badly those who entered into combat with its author came off in the end, some of them in what they consider their witty replies committing suicide so far as their reputation as authorities on art went. Notable is the case of the critic of *The Times*, replying "I ought to remember your penning, like your painting, belongs to the region of chaff." We have indicated the source of Whistler's success as a wit—at that source we find the reason why he always scored when talking about painting. He is playing something more than a game of repartee. His best replies are crystallised from his inner knowledge. In them we get bit by bit the revelation which he had received as a genius in his craft.

It was the force of his personality that obtained for Whistler's evasive art such recognition in his lifetime as in the natural course only falls to fine painters of the obvious, whom every one delights to honour. He had said that "art is for artists," and it is true that the perfection of his own

art is the pleasure of those who study it. It reached heights of lyrical expression where life in completeness has not yet been represented in painting; reached them perhaps because so lightly freighted with elementary human feeling. His work so often leaves us cold, and we turn seeking for art mixed further with the fire of life and alight with everyday desire.

But nature showed many things to this her appreciator—I write, her intimate friend. As a moth which goes out from the artificial atmosphere of a London room into the blue night, I think of the painter of the nocturnes—yet always as a lover of nature, never more so than when his subject is the sea. For he has a greater consciousness of the salt wet air than any other sea painter, of the veil behind which all ships are sailing and through which the waves break, the atmosphere which descends so mystically and invisibly and yet which if not accounted for in a canvas leaves ships with their sails set in a vacuum and the waves as if they were crested with candle-grease. Is it not absence of this atmosphere which has tortured us on so many occasions when with everything quite real a picture has not brought us pleasure. Pleasure comes to us always with reality in art, and the end of art is realism. All is real even around a mystic, though his thoughts are out of our sight. Whistler was not a mystic but above everything he wished to suggest the atmosphere which is invisible except for its visible effect, and I cannot help thinking his vision essentially abstract.

He did not paint subject pictures. To make our meaning quite clear, let us say such pictures as Frith's, or better still, as Hogarth's in which we have the extreme. The art of Hogarth moved upon a plane lower down, but there it had a strength unknown to Whistler, a careless and lavish inspiration of life

PLATE V.—LILLIE IN OUR ALLEY
(In the possession of John J. Cowan, Esq.)

This study in brown and gold was made about the time (1865) when the Little Rose of Lyme Regis was painted, one of the most beautiful portraits of an English child. The latter picture unfortunately left these shores and is now in the Boston Museum, U.S.A.

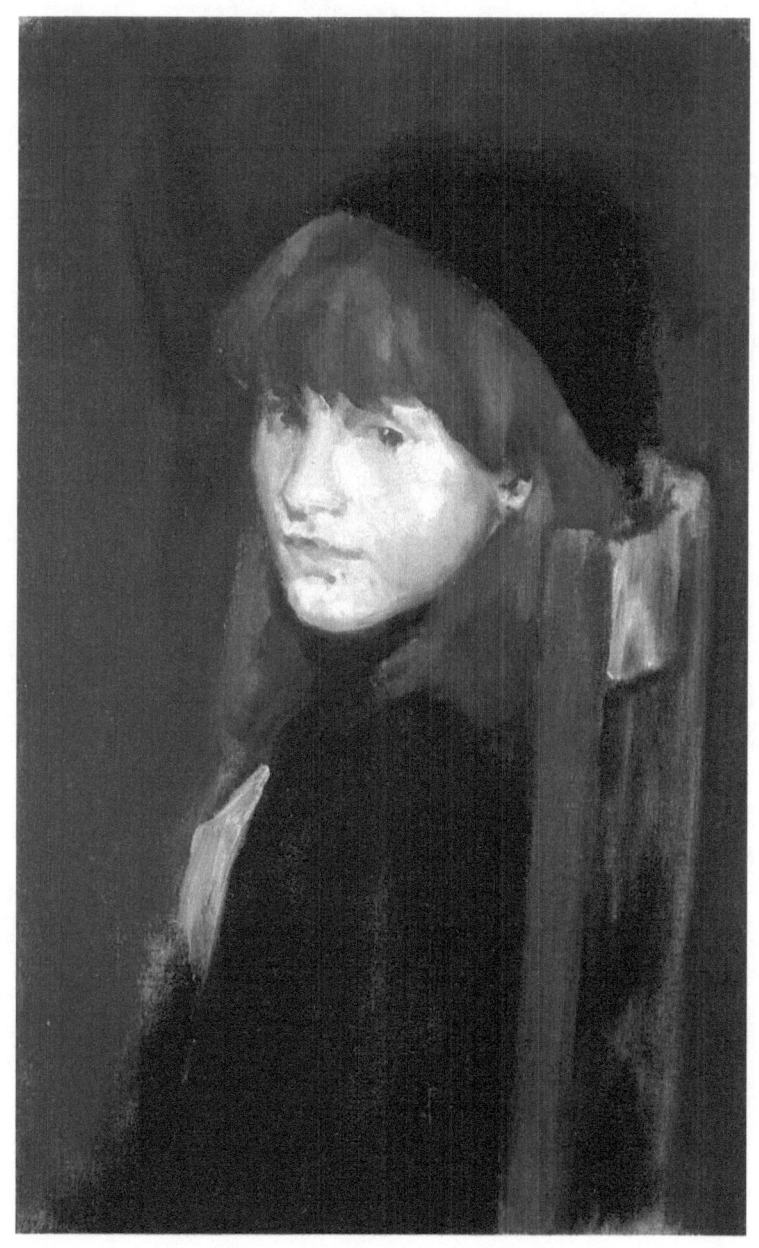

itself. He had to find speech for all sorts of things in his art, beauty was but one of these, creeping in less as a deliberate aim than as the accident of a nature artistic. Whistler in painting desired to express nothing but his sense of beauty. For the rest of his nature, he found expression altogether outside his art in enthusiasm for life itself, its combats, difficulties, and its opportunities for saying brilliant things at dinner. His dinner conversation, I have been told, was like the abstract methods of his etching, always cryptic, full of suggestion,— wonderful conversation, full of short ejaculations which carried your imagination from one point to another with hints that seemed to throw open doorways into passages of thought leading right behind things.

He had a remarkable regard for purity of speech, as became the painter of such spiritual types of womanhood. It would seem that women liked him, and readily apprehended in his art his sensitive view of life. At table he drank but little and was a slender eater. When alone he would sometimes forget all about his meals, or eat scarcely anything; in later years, feeling the necessity of taking care of himself he would guard against his indifference by always seeking companionship when away from his house. His nervous disposition forced him to content himself with little sleep, his active brain keeping him awake conceiving witticisms and planning the battle for the morrow.

IV

IT would be incomplete in any memoir of Whistler to omit the most thrilling battle of his life. To all adventurers there comes at last the event which knocks all their venturousness out of them or is the beginning of a triumphant way. Whistler had been before the footlights a long time, but it was his contact with Professor Ruskin which brought him into the full lime-light, which he was so much prepared to enjoy. Ruskin paid him the only tribute strength can pay to strength when it is not on the same side—with a prophetic instinct that as regards picture exhibitions Whistler's art was the sign of a coming, and licentious, freedom from the old rules of the game. He saw in Whistler's work the end of old fair things, the laws of those old things all set aside. In reading the so well-known criticism of Whistler one has a feeling that after all Ruskin has only half expressed his feelings in it—however it resulted in the famous libel action. Whistler received one farthing damages, which sum he afterwards magnanimously returned to his eminent critic, as his contribution towards the subscription set on foot to pay Ruskin's legal expenses.

Ruskin's criticism was as follows:—

"For Mr. Whistler's own sake, no less than for the protection of the purchaser, Sir Coutts Lindsay ought not to have admitted works into the gallery in which the ill-educated conceit of the artist so nearly approached the aspect of wilful imposture. I have seen, and heard much of cockney impudence before now, but never expected to hear a coxcomb ask two hundred guineas for flinging a pot of paint in the public's face."

The case came on in the Court of Exchequer Division before Baron Huddleston on November 15, 1878, Whistler claiming £1000 damages. "The labours of two days, then, is that for which you ask two hundred guineas!" asked the Attorney-General representing Ruskin. "No," replied Whistler, "I ask it for the knowledge of a lifetime." "Do you think now that you could make me see the beauty of that picture?" asked the Attorney-General. "No!" he replied. "Do you know I fear it would be as hopeless as for the musician to pour his notes into the ear of a deaf man." In resuming the Attorney-General said: "Let them examine the nocturne in blue and silver, said to represent Battersea Bridge. What was that structure in the middle? Was it a telescope or a fire-escape? Was it like Battersea Bridge? What were the figures at the top of the bridge? And if they were horses and carts, how in the name of fortune were they to get off?"

Mr. W. P. Frith, R.A., was examined and in his evidence said that in his opinion Mr. Whistler's pictures were not serious works of art. In the margin of the account of the trial in "The Gentle Art" Whistler quotes from that painter's "It was just a toss up whether I became an artist or an auctioneer," and adds, "He must have tossed up." There was a time when policemen had to keep the crowd away from Frith's Margate Sands. There was a time when Whistler's pictures were hissed when they were put on the easel at Christie's? If the attitude towards these so different kinds of art is changed, it is the resolution Whistler showed in life as well as in his art that changed it. And have we not in the above interchange of points of view at the court the whole vexed question—the issue around which the battle of Whistler's life always raged? Whistler explained to the court that his whole scheme was only to bring about

a certain harmony of colour. He tried to dispel the illusion that the painter's craft forms itself upon the desire to communicate a story. It may be so with the literary craft, but there is no life in the drawing or painting that is not inspired by the delight of the artist in the mere outside of things. Where there is the expression of that delight, there may be the expression of much beside, of the spiritual meanings behind all beauty—though Whistler did not take this flight in his reply. He himself tried to limit the meaning of art almost as narrowly as Ruskin. He had this advantage over Ruskin, that whatever he said about painting was from the inside knowledge of his genius in painting. Ruskin's genius was always approaching that subject from the outside. We could not on any account dispense with what was said at any time by either of them. It was impossible for them to see each other except as enemies across a wide gulf, all speech with each other drowned by the rapids of misunderstanding. The gulf is nearly bridged. In viewing art in its relation to life no one wrote more profoundly than Ruskin, but he failed in knowledge of the beautiful and inner mysterious delights of the craft of painting. Whilst exalting the mission of painting, he degraded its craft, he seemed to fail in appreciation of the fact that at its highest this is as mystical as inspired—and as unaccountable as the craft in Shelley's lyrics. The number of rules he laid down, the gospels he preached upon them reveal always the irritating scholiast and pedant. How eloquently Whistler expresses his irritation in the Ten o'clock lecture!

In his account of the trial in "The Gentle Art of Making Enemies," Whistler fills the margin with quotations from Ruskin so dexterously opposed to the matter in hand as seemingly to discredit for ever Ruskin's writings upon art and the mode of

thought therein. But at the bidding of Whistler, and those who boast his opinions second hand, we cannot abjure all this order of thought. One passage which Whistler quotes: "Vulgarity, dulness, or impiety will indeed always express themselves throughout, in brown and grey as in Rembrandt" is not without its bearing on his own art—which has since then quite altered the meaning of the word grey. And despite the perhaps unfortunate naming of Rembrandt one divines that Ruskin is here speaking in the light of the highest intuitive knowledge.

It must be remembered that in prose, which may accept its motif from anything, from art if it likes, Ruskin could sometimes lose himself as completely as Whistler often did in the beauty of his own art. And with the waters of beauty closing over their heads, one was as deaf and blind as the other. That trial was Ruskin's Waterloo. If there is one thing that would make me doubt that Whistler was a great man, it is the fact that he never had a Waterloo, but perhaps that is reserved for those who have been successful right from the beginning. The light air with which Whistler carried his own early troubles is misleading as to their extent. Without the thread of coarser stuff that crossed his otherwise over-refined nature some such sadness of fate might have awaited him as awaited Meryon, the French etcher, for possessing motives too far in advance of those accepted by his time. For really at first no one hardly seemed to have understood the delicate order of things that Whistler was trying to do, especially in his later etchings, in which everything is a symbol counting upon our imagination; everything a pleasure to its creator and nothing a labour; every line one of nervous impulse, the whole etching an inspiration of such impulsive threads. In what loneliness he must have possessed his abnormal delicacy of perception.

He hugged to himself the delusion that a knowledge of his craft enabled artists to understand him—but it is common for artists of abundant gifts not to have the necessary refinement of sense, and after all artists are not so numerous that these appreciators will be many. But in the wide world outside the studios there are many people thus delicately attuned, their numbers to be increased when Whistler in his subtlety of vision is less ahead of the world in point of evolution. He brought recognition to himself before his time by strident challenges, aggressive at every point and scornful—as they could not have been had the real nature of his superiority dawned on him at the first. In the first Thames etchings he has not received his revelation: they do not show his hand quite so conscientiously, nervously, awaiting its inspiration for every movement.

Nothing can make us realise the great significance of the Whistler influence in art more than the contrast between the esteem in which his etchings are now held and the early criticisms of them which he collected and scornfully embodied in his book. These are indeed the most depressing reading—and Whistler's quaint termination to those pages, "they roar all like bears," does very aptly express the feeling of desolation that must overcome any one who appreciates the spirit of his etchings. When praise is forthcoming it is only for the early etchings at the expense of those later ones in which he conceived such an inspired use of the needle. By the criticisms in this book we know the exhausting struggle and how right it was that a life, the first half of which had been spent thus, should have no "Waterloo," but end with rest—and with honour, accorded to this "Merlin," so evidently great, if only a few knew why.

It was 1878, the year of the Ruskin trial, that he started

PLATE VI.—NOCTURNE, BLUE AND SILVER

(In the possession of the Hon. Percy Wyndham)

Painted at Westminster, looking towards Lambeth. On the back of the picture is a card bearing the artist's signature and the butterfly, with title "Westminster, Blue and Silver, J. McNeill Whistler, 2 Lindsay Houses, Old Chelsea." This places the date of its execution about 1866.

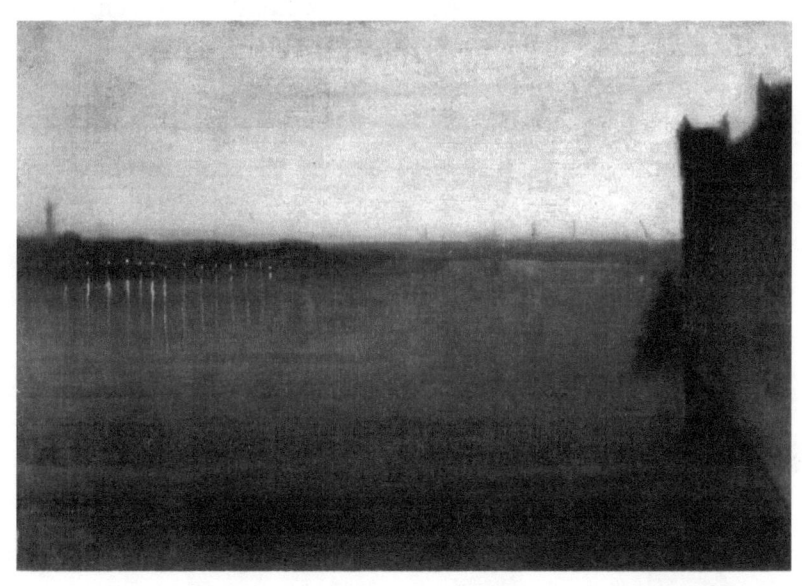

working in lithography as a medium, being initiated into the technicalities by Mr. Thomas Way. In the "Fair Women" Exhibition held by The International Society, which is open whilst I write, there are some lithographs by Whistler, which suggest purity of type and the charm of beautiful womanhood in a manner that puts to flight the claims of many a famous canvas in the gallery. It is the most delicate of all mediums; it suited his touch and the sensitive order of his perceptions.

After the Ruskin case Whistler left London for Venice for about a year; upon his return he exhibited at the Fine Art Society the first series of Venice pastels, and a little later at the same gallery fifty-three pastels of Venice. He also held exhibitions at the Dowdeswell Gallery in 1883, Etchings in 1884 in "Notes, Harmonies, and Nocturnes," in 1886 all the time still continuing to exhibit at the Grosvenor Gallery some of his most famous portraits, nocturnes, and marines.

V

ON 31st December 1884 the following amusing letter appeared in *The World*, signed with the well-known butterfly. "Atlas, look at this! It has been culled from the *Plumber and Decorator*, of all insidious prints, and forwarded to me by the untiring people who daily supply me with the thinkings of my critics. Read, Atlas, and let me execute myself. 'The "Peacock" drawing-room of a well-to-do shipowner, of Liverpool, at Prince's Gate, London, is hand painted, representing the noble bird with wings expanded, painted by an Associate of the Royal Academy, at a cost of £7000, and fortunate in claiming his daughter as his bride, and is one of the finest specimens of high art in decoration in the kingdom. The mansion is of modern construction.'

"He is not guilty, this honest Associate! It was I, Atlas, who did this thing—alone I did it—I 'hand painted' this room in the 'mansion of modern construction.' Woe is me! I secreted, in the provincial shipowner's home, the 'noble bird with wings expanded'—I perpetrated in harmless obscurity, 'the finest specimen of high-art decoration'—and the Academy is without stain in the art of its member. Also the immaculate character of that Royal body has been falsely impugned by this wicked *Plumber!* Mark these things, Atlas, that justice may be done, the innocent spared, and history cleanly written."

Whistler's picture "La Princesse du Pays de la Porcelaine" had been hung by Mr. F. R. Leyland in his mansion at Prince's Gate, and Whistler could not reconcile himself to its appearance against the valuable Spanish leather on the walls. He

was to correct this by treating a little of the wall; meanwhile Mr. Leyland went down into the country. When he returned it was to find that Whistler was painting over the whole of the room. Much money had already been spent on the original leather scheme, and Whistler had quickly effaced all appearance of its intrinsic worth, but he was in the rapid process of creating the famous Peacock Room. Dissension took place as to terms under the circumstances, and Whistler finished the room with a panel of two peacocks fighting, emblematic of the quarrel. Mr. Leyland was considered one of the most discriminating patrons of his time. Just previous to the above events the interior of the house had been reconstructed and decorated in accordance with designs by Norman Shaw and Jekyll. The leather had been the latter architect's scheme for the room where the "Princesse du Pays de la Porcelaine" was hung. The walls were fitted with shelves designed for the display of blue china. Whistler painted all the window shutters with gold peacocks on a blue ground, and a panel at the end of the room, which had been reserved for a picture commissioned from him; into this panel he put the fighting peacocks, whose eyes were real jewels, the one a ruby and the other a diamond. It was found possible to move all the decoration without injury and some time after the original owner's death this was done, the purchaser taking it to America. Before it left England it was set up temporarily for the purpose of its exhibition at Messrs. Obach's Gallery. The picture "The Princesse du Pays de la Porcelaine," the key-note, was however missing from the scheme, having found another purchaser.

The room was the finest example of a less known side of Whistler's art. His designs sprung straight from himself, they had no connection with any European tradition. He accepted

V

ON 31st December 1884 the following amusing letter appeared in *The World*, signed with the well-known butterfly. "Atlas, look at this! It has been culled from the *Plumber and Decorator*, of all insidious prints, and forwarded to me by the untiring people who daily supply me with the thinkings of my critics. Read, Atlas, and let me execute myself. 'The "Peacock" drawing-room of a well-to-do shipowner, of Liverpool, at Prince's Gate, London, is hand painted, representing the noble bird with wings expanded, painted by an Associate of the Royal Academy, at a cost of £7000, and fortunate in claiming his daughter as his bride, and is one of the finest specimens of high art in decoration in the kingdom. The mansion is of modern construction.'

"He is not guilty, this honest Associate! It was I, Atlas, who did this thing—alone I did it—I 'hand painted' this room in the 'mansion of modern construction.' Woe is me! I secreted, in the provincial shipowner's home, the 'noble bird with wings expanded'—I perpetrated in harmless obscurity, 'the finest specimen of high-art decoration'—and the Academy is without stain in the art of its member. Also the immaculate character of that Royal body has been falsely impugned by this wicked *Plumber!* Mark these things, Atlas, that justice may be done, the innocent spared, and history cleanly written."

Whistler's picture "La Princesse du Pays de la Porcelaine" had been hung by Mr. F. R. Leyland in his mansion at Prince's Gate, and Whistler could not reconcile himself to its appearance against the valuable Spanish leather on the walls. He

was to correct this by treating a little of the wall; meanwhile Mr. Leyland went down into the country. When he returned it was to find that Whistler was painting over the whole of the room. Much money had already been spent on the original leather scheme, and Whistler had quickly effaced all appearance of its intrinsic worth, but he was in the rapid process of creating the famous Peacock Room. Dissension took place as to terms under the circumstances, and Whistler finished the room with a panel of two peacocks fighting, emblematic of the quarrel. Mr. Leyland was considered one of the most discriminating patrons of his time. Just previous to the above events the interior of the house had been reconstructed and decorated in accordance with designs by Norman Shaw and Jekyll. The leather had been the latter architect's scheme for the room where the "Princesse du Pays de la Porcelaine" was hung. The walls were fitted with shelves designed for the display of blue china. Whistler painted all the window shutters with gold peacocks on a blue ground, and a panel at the end of the room, which had been reserved for a picture commissioned from him; into this panel he put the fighting peacocks, whose eyes were real jewels, the one a ruby and the other a diamond. It was found possible to move all the decoration without injury and some time after the original owner's death this was done, the purchaser taking it to America. Before it left England it was set up temporarily for the purpose of its exhibition at Messrs. Obach's Gallery. The picture "The Princesse du Pays de la Porcelaine," the key-note, was however missing from the scheme, having found another purchaser.

The room was the finest example of a less known side of Whistler's art. His designs sprung straight from himself, they had no connection with any European tradition. He accepted

in their entirety the conventions, the arrangements and devices of the Japanese designers. Yet his designs could not have been created by any of the great artists of Japan. There is too much vitality about them, and these peacocks which belong to a pattern and are conventionalised to the last degree, have a more startling reality than any peacock painted in a modern picture. No one knows how Whistler came to know so much about peacocks. A duffer can paint the bird until he comes to the neck—and then we have to turn to photographs for the reality that gives us pleasure, it eludes all modern genius. So for the most part, fortunately, peacocks are left severely alone. The dancing of the *première danseuse* at the Empire, perfected with ardent years of study, is a less recondite theme of movement than a peacock raising its head. It is a delight, to all those who love it, beside which all dancing pales, more gracious and stately in movement than the accumulated grace of many women. That is how it must always seem to those who really know it. Whistler arrived at perfect understanding by the instinctive route on which he never went astray.

After the peacock-room incident the wildest legends were afloat about the whole matter, one of them that the architect had been driven mad by the sight of what had happened to his leather, and that later he was found at home painting peacocks blue and gold all over the floor.

VI

IN 1885 Whistler's lecture on art was given in London, Oxford, and Cambridge; to suit the convenience of Londoners who liked to linger over dinner, he fixed the hour of delivery rather later than usual. This was the famous "Ten o'clock lecture"—so vague and shadowy in its facts at the beginning, so brilliant at the end, and dispelling the æsthetic fog in which the æsthetes elected to dwell. It is significant of the slight heed given to Whistler's real beliefs that characteristics of his appearance were at one time satirised in W. S. Gilbert's "Bunthorne," confusing him as was common with the æsthetic craze. In "The Ten o'clock" his scorn is eloquent enough of the weird cult "in which," as he says, "all instinct for attractiveness—all freshness and sparkle—all woman's winsomeness—is to give way to a strange vocation for the unlovely—and this desecration in the name of the Graces!" But for all that the principles which governed in L'art nouveau which followed and may be said to be a part of the movement, are prominent in those two "arrangements" of his own, the portrait of Carlyle and the portrait of his Mother.

No doubt the fame of an *objet d'art* can last for ever with connoisseurs, if rare enough in itself and rare in the skill displayed, and many a painting is destined to live on these same grounds. But there is a destiny too for the spirit of a picture of which all this valuable perfection is but the outward shrine. Where human experience rises to intensity of expression in art it is born into life anew and less perishably. It is thus that the picture of Whistler's Mother is by common consent enthroned

above the level of criticism, what we say for and against it being only as water lapping at the foot of a cliff. Incorporate with the traditions of a race it is acknowledged a classic, and of a classic one may speak as one does of life, with freedom as to how it affects oneself. I have challenged the effect of this picture upon myself. The trail of the age seems over it, the self-consciousness which is like a blight upon modern arts and crafts. Instead of its figure being painted in some such accidental contact with its environment as would naturally occur, we have an *arrangement*. In rearranging things thus for itself, art is at least one remove farther away from things as they are, and as things as they are reflect the influences that brought them together, art must come closer to life by the interpretation of this reflection than by its alteration. There must be an arrangement in every picture, but the improbability of this one, outside of a studio, spoils the picture for me. The figure is placed in position as we should place a piano. It is not very likely that a lady would sit at right angles to the wall with no fire in front of her, no work-table, no books. These thoughts rise unbidden when I look at the picture—but Whistler begs us in a printed letter to consider it as an *arrangement*. Incidentally, he says it is interesting to him as a portrait of his mother. Yet he misunderstood when he thought the artist's rights extended beyond his creations to the attitude in which one should approach them, and the picture is famous for the beautiful rendering of the lady and to us only incidentally interesting as an arrangement. One does not escape the music of the outline of the figure in the picture, the balance of all parts of the design, the refreshing convention in comparison with other conventions. Only conventions perhaps are best left for portraits where the traditional environment connected

PLATE VII.—PORTRAIT OF THOMAS CARLYLE
(In the Corporation Art Galleries, Glasgow)

This portrait is in the possession of the Glasgow Corporation, the only public body in these islands whose appreciation of the painter was not belated. In spite of protests, to their credit the purchase was made, and direct from the artist for £1000. The picture was first seen at the artist's exhibition in 1874, and was painted in the same period as the "Portrait of My Mother."

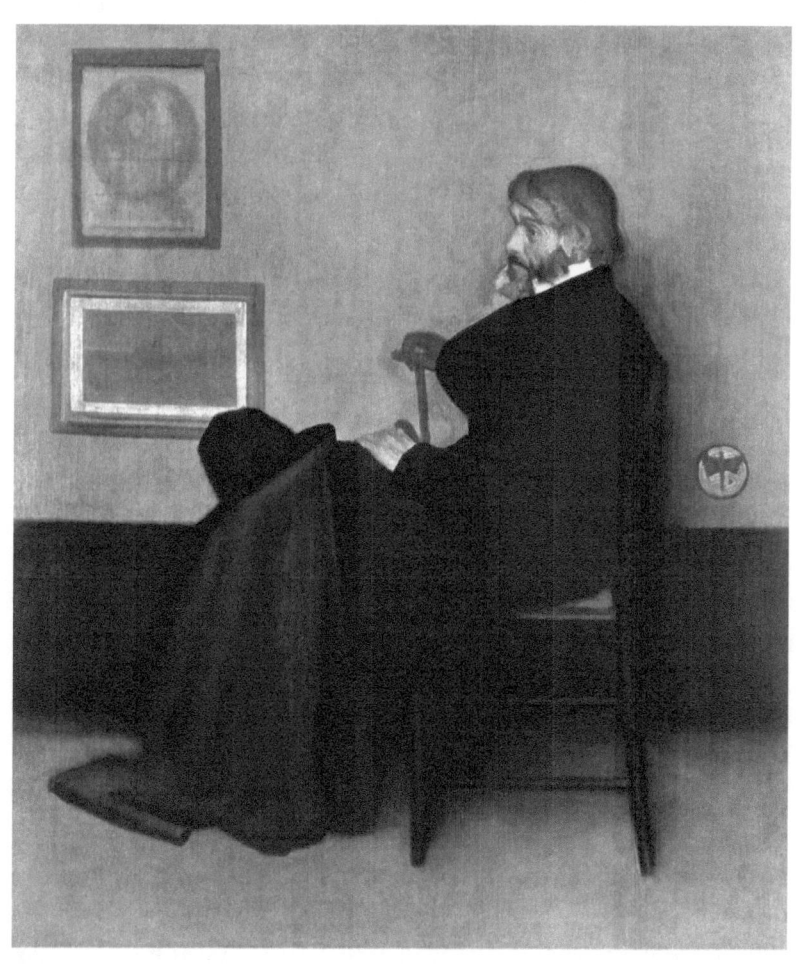

with the high social status or office of the sitter, supplants in our imagination the more everyday aspect of their life. The unnaturalness of the photographer's art may require concessions from every one; though even here as in painting, the art which conceals art must save the situation; and Whistler managed this gracefully enough in all his other portraits.

It was Gainsborough who was haunted by the smile of a woman. It is Whistler who represents her movement as she turns into the room, his art seeming to show a consciousness that the body that turns thus, the grace of the clothes, are but a temporary habitation of swiftly passing spirit.

In his early piano picture the trembling white dress of the child surprises him into the representation of stuff itself; later his art passes to an almost ecstatic obliviousness to the quality of things themselves and he surrenders the representation of their surface qualities for a fluid, musical, all-embracing quality of paint in which the artist can render his theme as a virtuoso, ever striving to overtake some almost impossible inflection of tone. And as his art becomes thus abstract, as it assumes such a mission as music, he finds musical terms for the names of his pictures to give the public the clue.

His water-colours are executed with an extremely pleasant touch of brush to paper in which he himself delighted, and here, as also in the case of etching, he made the most of the particular qualities of the medium and as ever was careful not to out-step the limitations which an appreciation of those qualities imposed. They do not do much more than register the incident of colour which interested him in any particular scene. It was to register his pleasure in that, rather than to make a full record of surrounding country that he made his water-colours, and the spectator will understand them only by

the responsiveness of his imagination to artistic suggestion.

By the process of what is termed in the language of art "suggestion" (that is, interpretation by thoughtful, economical, and expressive touches instead of a photographic imitation) all merely mechanical labour is eliminated and there is a consequent spiritualising of the whole method by which the artist makes his communication to our imagination. He infers that we have advanced beyond an understanding merely of the capital letters of art, and that this autographic handling of the brush or etching needle is as intelligible to us as the characteristic penmanship of our friends and as charming.

VII

THE second great public event in Whistler's career was his election in 1886 to the Presidency of the Society of British Artists in Suffolk Street, which made exciting history at the time. Whistler was just one of those people who want everything in the world arranged after some secret pattern of their own. They make the best reformers. But what could be a more strange spectacle than the revolutionary Whistler in the presidential chair of the staidest of art societies? The desire for advertisement overcoming the scruples of older members, Whistler's election as a member took place just before their winter exhibition in 1884. *The Times* of the 3rd of December 1884 recorded the fact that artistic society was startled by the news that this most wayward of painters had found a home among the men of Suffolk Street—of all people in the world.

His humour did not forsake him in this new environment. Mr. Horseley, R.A., lecturing before the Church Congress, attacked the nude models, especially and in particular at the Royal Academy Schools. Shortly after this, in sending a pastel of a nude to the Society of British Artists, Whistler attached the words "Horseley soit qui mal y pense," and was only prevailed upon to remove them by the fear of older members that the attack upon an Academician might lead up to a libel case with the Royal Academy. The Royal Academy students at the time used to drape the legs of the chairs and tables when Mr. Horseley visited the schools. That was in 1885. It was the following year that Whistler was elected President of the Society for which he got a Royal Charter, and to which by

his methods—as President—he brought fame for ever as the R.B.A.

Many of the electors who had supported his membership had concluded that he was not likely to take much part in the workings of the Society. However, he came to the meetings and to their surprise took an interest in the proceedings, proffering advice, intruding new ideas, not often welcomed by the older artists. He invited some of the members to one of his famous Sunday breakfasts at his studio in Tite Street, and regaled them with his theories of art. They were influenced by his personality and the character of the elections altered, men of the newer movements were elected, and they soon formed a small but very energetic and loyal group around Whistler, finally acquiring sufficient power to elect him as we have shown into the President's chair. After that the meetings of the Society were exhilarating in the extreme, and Whistler talked with extreme brilliance to the members, and somehow got his way until their Gallery was hung with one line of pictures upon a carefully chosen background.

But the opposition became too strong from members who wished to run the exhibition on its old lines, and certainly the funds were suffering from these very high ideals. His opponents "brought up the maimed, the halt, and the blind," "all except corpses, don't you know!" as Whistler put it, the oldest members, the fact of whose membership had up to that time lingered only perhaps in their own memory, and thus effected his out-voting at the next election. Whistler congratulated them, for, as he explained, no longer was the right man in the wrong place. "You see," he said, referring to the group of his followers who resigned with him, "the 'Artists' have come out and the 'British' remain."

It was the first time in England that pictures had been so artistically arranged. No pictures were badly hung, no member had anything to complain of as far as that went. But they were disturbed at the loss of probable sales which they calculated the empty spaces on the walls might be taken to signify.

On the night of the election which ended the Whistler dynasty there was great excitement, and the younger members let off steam by playing in the passages during the counting of the votes.

The Society had come into existence with aims of its own. An order of art was represented which had to be represented somewhere. A great amount of capable work for which the Academy had not room was on view here, representative of the everyday activity of London studio life. It was amusing to think of Whistler as the President of this Society as it was constituted in those days—and absurd. He could have nothing in common with its homely aims. But it was an advertisement for the Society and for him, he probably did not share the illusions of his followers that he was in the right place.

When in after years the leaders of the modern movement formed themselves into the International Society, in 1898, through the organisation of Mr. Francis Howard, it was inevitable and natural that Whistler should be the President, but at the British Artists it was simply a case of cuckoo and the sparrow's nest. With his success, the original element of the Society must have gone elsewhere leaving him in possession of their building.

It was fitting that Sir Joshua Reynolds should be the President of an Academy whose theories he embraced but exposited with greater genius. But Whistler's theories had no relation whatever to the body of which he was thus made the head, and

he did not surpass in everything as Sir Joshua; the significance of his genius resting rather with the fact that it is epochal.

However, as all this affair happened just at the time when paradox was coming into vogue, there was that much only about it that was fitting. After these events Whistler, who was invited on to the Jury of the "New Salon" then forming, left for Paris.

PLATE VIII.—IN THE CHANNEL
(In the possession of Mrs. L. Knowles)

In this impression of grey sea-weather we have the colour equivalent of that expressive economy which Whistler practised with his line; and the butterfly touch—like a butterfly alighting.

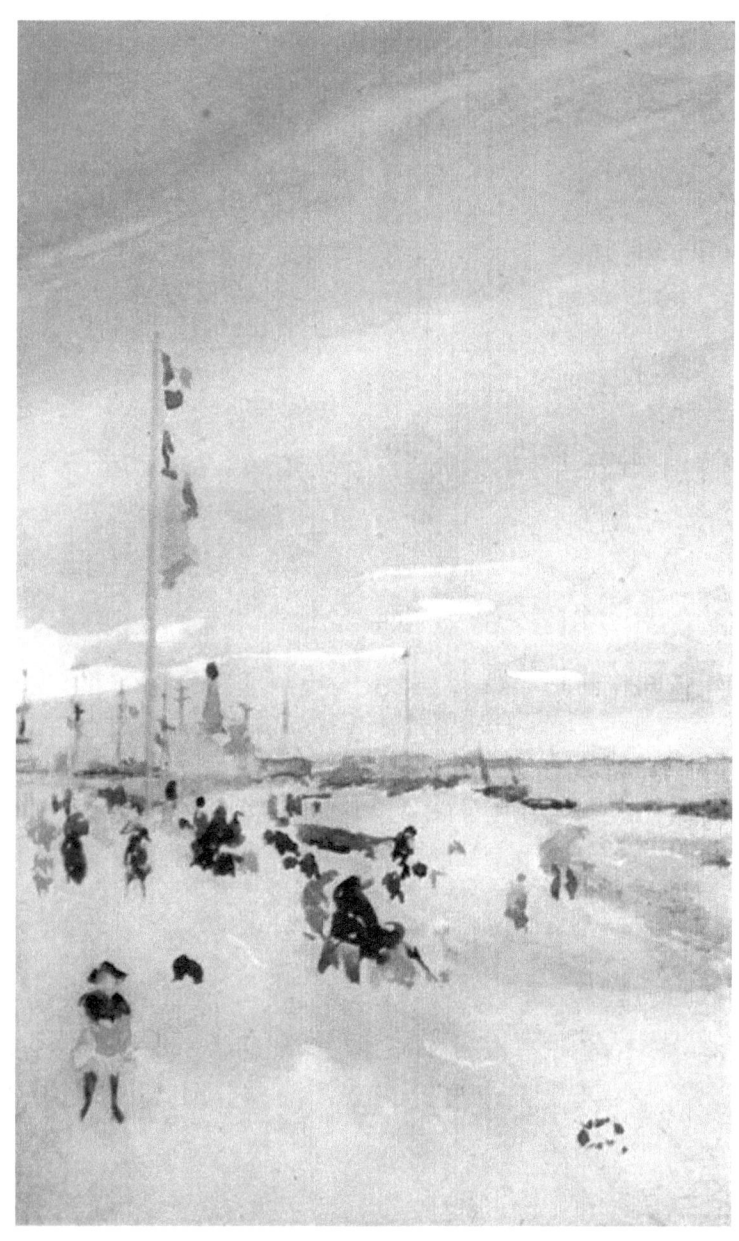

VIII

IN 1892 the painter returned and held an exhibition at the Goupil Gallery, and from the date of this exhibition everything altered in his favour. For years he had found it impossible to sell his pictures except to a circle of wealthy patrons. The prejudice excited against his work after the issue with Ruskin had closed all other markets for him. He had remained the "impudent coxcomb" in so many people's minds, and his challenge to the omnipotence of Ruskin had not been forgiven him. A ban was upon his works. He said that for nearly twenty years the Ruskin case affected his sales. But fame he desired more ardently, and this he had,—like Prometheus,—and of a kind that would keep till the day came when it could be changed for a quantity of money. When the Goupil show was open he found this day was already upon him, and the Americans coming over, began to buy his works, and early acquaintances who had acquired them at small prices, themselves sold out, of course much too soon. That was the time when a purchase for the nation should have been made.

Later he toured through France and Brittany until he settled again in Paris in the Rue de Bac, having married Mrs. E. W. Godwin, the widow of the eminent architect, builder of the White House in Tite Street, Chelsea, which had been Whistler's former home. In the old days in the White House he had furnished one or two rooms elaborately, and others, perhaps for lack of funds to make them perfect, hardly at all. It was then he collected the blue china with Rossetti as a friendly rival. This was the house in which he instituted his famous Sunday breakfasts, and to which everybody used to

come who was distinguished. The breakfast-time was twelve o'clock, cook permitting. On one occasion, through some untoward circumstances in the kitchen, it was not placed upon the table until nearly three. Mr. Henry James was there that day, and has been heard to speak of it since, and how he took a walk to bring him nearer breakfast-time. But all this had to be given up after the expenses of the Ruskin Trial, and the blue china was "knocked down." Whistler wrote a characteristic letter to *The World* in 1883 upon the alterations then being made in the White House by his successor, one of "Messieurs les Ennemis" a critic. In those days his wit and vivacity had already made him a host of acquaintances, and distinguished men were glad to count him as one among themselves,—whilst reserving their opinion on his painting. But now things were very different, and he was referred to as "the Master"—and the house in the Rue de Bac thoroughly furnished, partly from designs made by his gifted wife.

He came to England in 1895 and painted at Lyme Regis, painting "The Little Rose of Lyme Regis"—which shows that his art is purely English—though he had said that one might as well talk of English Mathematics as of English Art. For in this little girl's face something there is that is only found in English Art. She descends directly from the beautiful tradition of Walker and Sir John Millais. In December he exhibited a collection of lithographs at the Fine Art Society's Gallery. He was again in London in 1896. About this time he painted upon a small scale an almost full-length portrait called "The Philosopher." It was of the artist, Holloway. Holloway died on the 5th March 1897, and in the sadness of the attendant circumstances the kindness of Whistler will always be remembered.

There were qualities in Holloway's art of which Whistler was appreciative, and a characteristic story can be connected with this. There is a picture of the sea in the National Gallery at Milbanke called "Britain's Realm," by John Brett, R.A. It had great success in its year, at the Academy. Everybody went to see it, and it was eventually bought for the Chantry Bequest. It had figured also in an exhibition of sea-pieces at the Fine Art Society. Whistler happened to be at this exhibition when somebody very enthusiastic over the picture brought him up to it expecting him to admire it also, but Whistler glanced at it through his eye-glass, turned and emphasising his words with a very significant gesture towards the representation of sea—as if knocking at a door—said with his sardonic Hé, Hé,— "Tin! if you threw a stone on to this, it would make a rumbling noise," and turning to a picture by Holloway said—"*This* is art!"

Also in this year Whistler was very preoccupied with the art of lithography. His wife was ill, and they were staying at the Savoy Hotel. Whistler used to sit at the window all day looking out upon the river, and in these circumstances he made one of the best series of lithographs. With the recovery of Mrs. Whistler they moved up to Hampstead, where he said "he was living on a landscape." At the same time he was renting a studio in Fitzroy Street, at No. 8, now called the Whistler Studios. In choosing it, Whistler had said, "After all, this is the classic ground for studios," and he had as neighbour a tried friend.

On May the 7th, 1896, Mrs. Whistler died, and she was buried on the 14th. The next day he came down to the studios and walked with his friend. They took lunch in the neighbourhood of Tottenham Court Road. Whistler spoke of the

strangeness of fatality. He had postponed his wife's funeral a day to escape the 13th, the 14th was her birthday. They sat on, Whistler in the deepest depression, and to divert him his companion, Mr. Ludovici, pointed to a print exactly over his head. It was of Frith's Margate Sands!

After the death of his wife, Whistler lived much in retirement, though travelling a little. He returned to Chelsea, and died there in his 70th year in July 1903. His life added as richly to its associations as the lives of his two great contemporaries Rossetti and Carlyle, both of whom are commemorated upon the embankment of the river close to the places where they lived. There is now a movement well on foot to place a memorial there to Whistler, to be designed by that other artist, Monsieur Rodin, who on so different a scale has been inspired by the same half mystic motives. To appeal to us, not with fairy tales, but with art imaginative in its deference to our imagination.

Whistler was without excessive, spendthrift, creative power. In many ways his art was slight. Yet even so, not because it is empty, but because it outlines for us so much that is only visible to thought, though thought always in relation to external beauty.

And the indefiniteness of his art, the grey of its colour, they are emblematic of the times, as the plain red and blue of Titian belonged to those days, and are resemblant of the plainer issues that then divided men's thoughts.

Admitting all his own limitations to himself Whistler admitted none of them to other people, and to those who divined his weaknesses at certain points he seemed somewhat of a charlatan. Perhaps in the near future his fame will again seem to suffer, from the strict analysis of the pretensions put forward

in his name, but if so, only to triumph again as the true character of his achievement comes to be distinguished.

He was such an instinctive artist that the explanation of his art must, to some extent, have remained hidden from himself, and Art fixing his place among her masters, will remember that great limitation in some ways is always the price of a new and instinctive knowledge in others.

www.ingramcontent.com/pod-product-compliance
Lightning Source LLC
Chambersburg PA
CBHW030019190526